What Artists Do

Leonard Koren

Imperfect Publishing

Point Reyes, California

For Emilia

Published by Imperfect Publishing
PO Box 608, Point Reyes, CA 94956 USA

Book design by Emilia Burchiellaro and the author.
Special thanks to Peter Goodman, Nan Weed, and
Kitty Whitman for their help in the making of this book.

Printed in Italy

ISBN 978-0981484662

"Only be an artist if you have no choice!"

—*Marilyn Minter, artist*

"There really is no such thing as Art.

There are only artists."

—E. H. Gombrich, art historian

Contents

"If we drop beauty, what have we got?"

—*John Cage, artist*

Introduction

Is art *really* important? If so, what are the evidence-based facts, the "metrics," that prove its importance? Or, is the value of art fundamentally not quantifiable?[1]

A premise of this book is that art is important because art is part of that nebulous, unquantifiable dimension of reality we sometimes call "the poetic." Religion, magic, and even love, beauty, and other forms of non-rational understanding also fall into this category. The poetic transcends the practical imperatives of life— and yet it is a building-block of the identities we assign to ourselves. The poetic is also (importantly) a well-spring of joy, hope, pleasure, and wonder. . . . It is a source of comfort and consolation when our fellow humans beings let us down, and when we feel that the universe really doesn't care . . .

Those who make art we call artists. Anyone can be an artist.[2] There are no tests to take, no certification required, and no particular skills needed. Similarly, anyone can call themselves an artist. (Conversely, anyone can be an artist but not call themselves one.) Accordingly, there are as many ways to be an artist as there are people on the planet.

Artists create from a subjective point of view:
- This is what I see.
 (Or would like to see. Or could imagine. . . .)
- This is what I hear.
- This is what I feel.
- This is what I think.
- This is what I believe.
- This is what I question.
- This is what I am curious about.
- This is what I want to manifest.
- This is what I am.
 (Or could be. Or would like to be. . . .)

"Painting is the best way I've found to get along with myself."

—*Robert Rauschenberg, artist*

"I don't teach because there really isn't anything I can teach, except what I do, which is the last thing that would be helpful to anyone but me."

—*Sol LeWitt, artist*

Artists are cognitively grounded in the aesthetic. That is, they are aware of, and think about, the sensory and emotive qualities of phenomena and things. Absolutely anything can be the object of aesthetic consideration, even things that don't seem in the least bit sensuous, like a series of random numbers or an abstract idea.

Every artist formulates their own problems to solve and sets their own criteria for success.

Artists do myriad things. Six of these things are discussed on the following pages. This limited (and arbitrary) sampling is intended to emphasize how, in totality, the work of artists has a substance, spirit, and methodology different from that found in most other types of work. Highlights from the lives of seminal 20th-century artists are used to illustrate these six things.

All of the artists featured in these vignettes, with at least one notable exception, make visual art with a pronounced conceptual bias. In other words, they are just as—or more—concerned with the ideas and concepts on which their artwork is based as they are with its physical expression. These artists, and the inspirational and influential artworks they produced, represent only a narrow spectrum of artist types and artistic media. They are, nevertheless, meant to serve as rough proxies for the contemporary artist archetype and for all works of art in all media.

"The process of painting is a series of moral decisions about the aesthetic."

—*Louise Nevelson, artist*

1. Determine what art is

Almost everyone agrees that artists make art, but few people agree on what, exactly, art is. Art continually appears in new and previously unimagined guises. The art of today may bear little resemblance to the art of the past. As a consequence, "art" is a word that is often intentionally left undefined.

How then, or rather who, determines what art is and isn't? For instance, who decides what is exhibited in art museums and art galleries? In effect it is those who make the art, i.e., artists.[3] With every new artwork, an artist brings a new manifestation of art into existence. However, if this new manifestation deviates too far from previous ones, there may be a problem. The artist then has to persuade others that what they have brought into existence is, indeed, art. One artist who expertly did this—got others to buy into his unusual conception of art—was Marcel Duchamp (1887–1969).

". . . art may be bad, good, or indifferent, but,

whatever adjective is used, we must call it art,

and bad art is still art in the same way as

a bad emotion is still an emotion."

—*Marcel Duchamp, artist*

"The reality in an artist's existence is to question answers."

—*Lawrence Weiner, artist*

Duchamp was born and raised in France. In 1915, in his late twenties, he came to live in New York. Duchamp made a number of noteworthy paintings and sculptures, but his major preoccupation was making art that questioned the philosophical premises of the domain of art itself. Duchamp asked through his art: Do artists really have to fabricate art artifacts with their own hands? Are certain materials more suitable than others for making art? What makes an artwork different from those things that look similar but are not works of art? And what, really, is art?

During his first decade in the United States, Duchamp worked diligently on what he hoped would be his masterpiece, an artwork that incorporated elements of painting, sculpture, and collage. It was constructed out of varnish, oil paint, lead film, dust, cracked glass, and aluminum foil—and was altogether encased in a wood and steel frame. It was titled "The Bride Stripped Bare by Her Bachelors, Even." (It was also known as "The Large Glass.")

While working on the "The Bride Stripped Bare . . . ,"
Duchamp also experimented with a new genre of
artwork he called the "readymade." A readymade was an
ordinary mass-produced functional object, or a combina-
tion of such objects, bought from a store and minimally
modified. Sometimes Duchamp added nothing more
than a signature, a date, and a title. His first readymade
was actually created in Paris before he came to Ameri-
ca. It was a bicycle wheel mounted atop a wooden stool.
His first New York readymade was a snow shovel. He
suspended it from the ceiling of an art gallery and titled
it "In Advance of the Broken Arm."

Two years later Duchamp fashioned what was to
become his most famous, or infamous, readymade.
It was an ordinary white porcelain urinal purchased at
a heating and plumbing supply showroom. Duchamp
added a date and signed it using the pseudonym
"R. Mutt." (This was probably a play on the name of the
business where it was acquired, J. L. Mott Iron Works.)
He titled it "Fountain."

Duchamp loved playing games, particularly word games and games of strategy.[4] In a very real sense, making art was a game for Duchamp. The readymades represented a move, not unlike a bold chess move, intended to advance his position in the game of art.

Duchamp played his game of art primarily in the context of arts institutions. Around the same time Duchamp created "Fountain" he also cofounded an organization whose stated purpose was to exhibit any and all works of art without judgment or restrictions. It was named the Society of Independent Artists. Any artist who paid a modest fee could enter an artwork in one of its shows. In 1917 the Society mounted the largest exhibition of modern art ever seen in the United States until then. However, when the hanging committee reviewed "Fountain"—submitted by an unknown artist named R. Mutt—the piece was determined to be not really a work of art but merely a "functional object." Duchamp, not coincidentally, was a member of the hanging committee. Without giving himself away, he

vigorously defended "Fountain" as an artwork, but the other members wouldn't budge. Duchamp understood that institutions, even well-meaning arts institutions, tend to be conservative no matter how liberal their founding ideals. Duchamp kept at it, but when he realized the futility of his protestations, he quit the committee.

The rejection of "Fountain" undoubtedly triggered a sense of déjà vu. Five years prior, in Paris, Duchamp had tried to enter a painting titled "Nude Descending a Staircase, No. 2" in an exhibition organized by the Société des Artistes Indépendants. This salon exhibition was established in direct response to the rigid traditionalism of the official government-sponsored salon (an annual art exhibition). It was supposed to embrace an artistically more enlightened point of view. (At the time, getting one's work accepted in a salon show was the primary way French artists established themselves as art-making professionals.) To Duchamp's dismay, the "progressive" organizers of this

"I have forced myself to contradict myself in order to avoid conforming to my own taste."

—*Marcel Duchamp, artist*

". . . as soon as you get to the why, you deal with 'Why not?'"

—*Ross Bleckner, artist*

exhibition bristled at the title "Nude Descending. . . ." They were also taken aback by the painting's subject matter. (Up until then nudes either sat or reclined, they didn't walk in Cubist stop-motion fashion down flights of stairs!) The show's organizers appealed to Duchamp's two older brothers, both established artists, to "manage" their younger sibling. For the sake of family harmony, Duchamp withdrew his artwork from consideration. But it must have rankled.

This time around in New York, Duchamp took another tack. He and a companion retrieved "Fountain" from the Society of Independent Artists' storage area and brought it to Alfred Stieglitz, an eminent American photographer. They asked Stieglitz to photograph it. They then reproduced the photograph in an avant-garde journal titled *The Blind Man* published, not coincidentally, by Duchamp and some friends. Accompanying the photograph was an anonymous defense of the work that read:

"They say any artist paying six dollars may exhibit [in the show]. Mr. Mutt sent in a fountain. Without discussion this article disappeared and never was exhibited. What were the grounds for refusing Mr. Mutt's fountain?
1. Some contended it was immoral, vulgar. 2. Others, it was plagiarism, a plain piece of plumbing. . . .

"Whether Mr. Mutt with his own hands made the fountain or not has no importance. He CHOSE it. He took an ordinary article of life, placed it so that its useful significance disappeared under a new title and point of view—creating a new thought for that object."

Through the force of a well-thought-out idea and dogged persistence, Duchamp was eventually able to surmount skepticism, derision—and even hostility—to see his concept of art fully sink into the art-world mindset. But it took almost thirty years to do so. By the 1950s, and even more emphatically in the 1960s, it would not be an exaggeration to say that Duchamp's

contribution to the modern art canon was tantamount to Albert Einstein's $E = mc^2$ formulation in physics. Einstein posited that a small amount of mass is convertible into an enormous amount of energy. Duchamp posited that any ordinary object can be converted into that special something called art—assuming that an artist can effectively convince others it is so. To this day, countless artists have based at least part of their artistic practice on this revolutionary principle.

4'33"

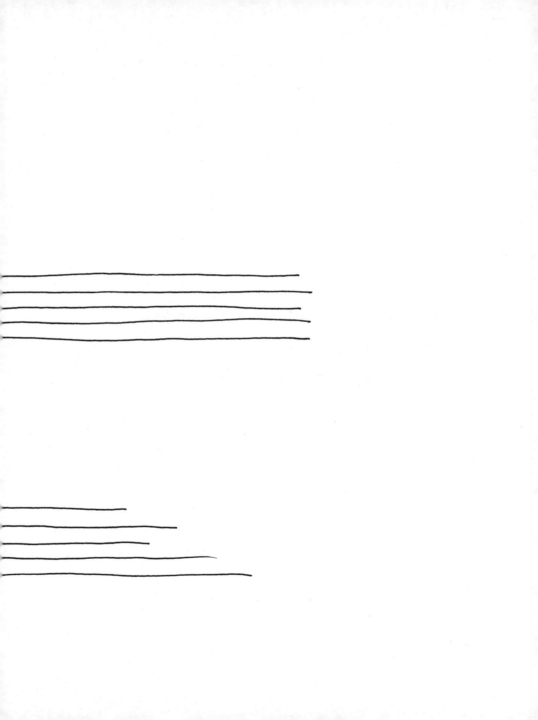

"The world is full of objects more or less interesting;

I do not wish to add any more. . . ."

—*Douglas Huebler, artist*

2. Make something from nothing

If, following from Duchamp, art can be created out of anything, then why can't it be made out of "nothing"? Indeed, some artists literally make art out of nothing, or what at first seems like nothing. (Or make art that seems to come from "nowhere.") A quintessential example of this is an artwork created by John Cage (1912–92).

Cage's primary medium was sound. Throughout his art-making life he was known for creating unorthodox music, or sonic artworks, that incorporated atonality and cacophony, or what is sometimes called noise. As part of his art-making methodology Cage often incorporated chance or unplanned actions. He used standard instruments, but in non-standard ways—like the sound of an orchestra tuning up. He also used non-instruments like hammers and bolts and screws . . . and radios for random snippets of talk and music programming, and for the static between stations.

Mid-career, Cage had an epiphany: why not create a composition in which there are no sounds at all? According to the artist, "[I wanted to] compose a piece of uninterrupted silence and sell it to Muzak Co." (Muzak, as the company was then named, sold recorded "mood music" for different commercial applications, such as in elevators and department stores.)

For all his apparent emancipation from conventionality, Cage was afraid that if he made a piece with no apparent sounds whatsoever people might think he was putting them on—and he didn't want that. Ultimately, two separate but related insights provided the conceptual grounding he needed to proceed.

The first insight came when viewing the all-white and all-black paintings of his friend, artist Robert Rauschenberg. At the time, monochrome paintings like Rauschenberg's were thought to be artistically "smart" because they were artifacts of pure painting. That is, they were paintings where the content and subject

matter are solely painting with no extraneous pictori-
al elements. Rauschenberg, however, had a different
way of thinking about it. "A canvas is never empty,"
he said. Cage took Rauschenberg's words to heart.
Cage remarked that Rauschenberg's all-white paint-
ings were "airports for light, shadows, and particles."

Cage's second insight came when he visited an
anechoic chamber at Harvard University. An anechoic
chamber is a room designed to maximally absorb
sound and attenuate echoes. Once inside the chamber
Cage thought he would find absolute silence. Instead
he heard two persistent sounds. One was high pitched,
the other low. He asked the attending acoustical
engineer what they were. According to Cage, the
engineer explained that the high tone was his nervous
system and the low tone was the blood circulating
through his veins and arteries. (Scientifically speaking,
humans cannot directly hear the sound of their nervous
systems, no matter how quiet the environment. The
nervous-system sound Cage thought he heard was

probably tinnitus, the hissing-like noise sometimes referred to as a "ringing in the ears." It is a fairly common condition that can be brought on by exposure to excessively loud noise. Cage's tinnitus may have always been in the background of his awareness, but the relative silence of the chamber brought it to the fore.)

Both episodes led Cage to understand that even if one tried to remove all sources of sensory stimulation—in his case sound—an unextinguishable amount of perceptible sensory content would exist nonetheless. The human mind, it seems, tends to seek differentiation even in ostensible sameness. Thus reassured, Cage set to work on an art piece that employed (and was about) the absence of intentional sound. He titled it "4' 33"."

The first performance of "4' 33"" occurred on a warm, rainy, summer evening in 1952. The venue was a small wooden auditorium located at the end of a dirt road in the middle of a forest near Woodstock, New York, an

artist community a few hours from Manhattan by automobile or bus. A large oak tree grew up and out through an opening in the roof. Many of those in attendance were from New York's classical musical community. Some were vacationing members of the New York Philharmonic Orchestra. Everyone was looking forward to the next new thing from Cage, who had established a reputation for his avant-garde sensibilities.[5]

The featured musician, a pianist named David Tudor, was a longtime Cage collaborator. The first piece performed consisted of Tudor's piano playing, a duck call, and sounds from a transistor radio. It was titled "Water Music." The second piece—"4' 33""—began with Tudor sitting in front of the piano and pulling out a stop watch. He started the timer and opened and then closed the keyboard cover. He followed this routine a total of three times to designate three intervals of silence that lasted a total of exactly 4 minutes and 33 seconds.

Of that premiere performance, Cage reflected, "You could hear the wind stirring outside during the first movement. During the second, raindrops began pattering the roof, and during the third the people themselves made all kinds of interesting sounds as they talked or walked out."

Cage later noted that he had worked longer and harder on "4' 33"" than he had on any of his other compositions. It also turned out to be his most popular and enduring work of art. It has since been performed innumerable times by myriad people. (It is legendary in the art world.)[6]

Over the years, Cage created at least four different versions of the score. In other words, using different musical notation schemes, Cage indicated how *not* to make sounds in at least four different ways. By so doing, Cage showed subsequent generations of artists how to make "real things" that exist only in the mind.[7]

"I have nothing to say

and I am saying it

and that is poetry. . . ."

—*John Cage, artist*

3. Stand out in a noisy and distracted world

Nobody *really* needs art. At least that is what some cynics say. So if artists want their work to be acknowledged, they have to figure out how to make the value of their creations apparent and compelling to others. This means first getting people to pay attention, then turning their attention into a sustained interest. Every artist does this in their own manner. Christo Vladimirov Yavacheff (1935–2020) and Jeanne-Claude Marie Denat (1935–2009), an art partnership commonly known as Christo and Jeanne-Claude, developed some unique and highly effective ways of attracting and holding the world's attention.

In his native Bulgaria, then a communist regime, Christo was a portrait painter. In his early twenties Christo escaped to Western Europe where he became enamored with the conceptual side of art. His art practice changed dramatically. He began wrapping small- to medium-sized objects with fabric or plastic

film. He then masterfully bound these "packages" with rope. He gave these artworks eponymous titles like "Wrapped Boxes," "Wrapped Mirror," "Wrapped Champagne Bottles," "Wrapped Bicycle on a Luggage Rack," "Wrapped Motorcycle," and "Wrapped Portrait of Brigitte Bardot." When wrapped, these relatively common things were magically transformed into something almost fetishistic. It was uncanny. It was so uncanny that it attracted a lot of attention.

Around this time Christo met, fell in love with, and subsequently married Jeanne-Claude. Jeanne-Claude helped Christo plan and execute grander, much more logistically difficult projects. For example, in 1969 Christo wrapped a 1½-mile-long section of the Australian coastline near Sydney. One million square feet of fabric was used. It was secured in place with 35 miles of rope. In 1985 Christo wrapped the Pont Neuf, the oldest bridge traversing the river Seine in Paris. And in 1995, after twenty-four years of behind-the-scenes negotiations, Christo and Jeanne-Claude wrapped the

Reichstag, the German parliament hall in Berlin.[8] (In 1994 Christo acknowledged that Jeanne-Claude's collaboration was absolutely vital in the making of the art. From that time on all projects were credited to both of them.) Because of the audacious size, the amount of time required to realize, and the social-political complexities of these projects, Christo and Jeanne-Claude's work became known and celebrated well beyond the insular art world.

Interspersed with their wrapping projects, Christo and Jeanne-Claude produced other kinds of monumental modifications of the environment. They hung 200,000 square feet of bright orange textile between two mountains in Colorado ("Valley Curtain"). They surrounded eleven islands in Florida with millions of square feet of pink, floating plastic fabric ("Surrounded Islands"). They erected thousands of massive, umbrella-like objects simultaneously in rural Japan and California ("The Umbrellas") . . . And they created "Running Fence," an 18-foot-high barrier made of translucent white nylon

"I'm only trying to do what I can't do."

—*Lucian Freud, artist*

"If you really want to separate your work

from everyone else's, every time you come to a Y

in the road, don't think about which way to go;

automatically take the toughest route.

Everybody else is taking the easiest one."

—*Richard Serra, artist*

cloth that rose out of the Pacific Ocean, crossed four-teen public roads, and ran for 24½ miles along the rolling hills of California just north of San Francisco.

With each new project Christo and Jeanne-Claude had to learn fresh skills: How to interpret the communica-tional nuances of exotic socio-cultural subsets. How to navigate the intricate pathways of yet another bureau-cratic labyrinth. And, of course, how to overcome novel technological challenges.[9] During the "Running Fence" project, for example, Christo and Jeanne-Claude had to obtain permissions from the fifty-nine different private-ly owned farms and ranches that the fence would cross. Many of the ranchers and farmers had never been to an art museum. Some initially responded, "Sorry, we build our own fences." Some thought the New York–based duo were con artists trying to work a land swindle. Yet, over time, dialogues began. "They had a knack for befriending people," according to one rancher. Through charm and persistence—and the promise of receiving all the fence-related materials

once the artwork was ultimately dismantled—the farmers and ranchers slowly came around. So did the local politicians and bureaucrats whose approvals were also needed. Altogether, over a period of forty-two months of one-on-one encounters, endless meetings, eighteen public hearings, and three sessions of the California Superior Court, permissions were granted, denied, contested, opposed, sustained, overturned, and regranted.[10]

Through it all Christo and Jeanne-Claude consistently contended that every personal, institutional, and legal interaction—even with vehement opponents—was, in fact, an integral part of the artwork. The artists were simply acknowledging a reality: The ultimate medium of art is freedom. The price artists pay for freedom is "taking responsibility." Put another way, artists are responsible for, and subject to, the consequences of everything that occurs within the experiential field they create or engender. If they break the law, they go to jail. If they offend social mores, they suffer the opprobrium

"An artist is responsible for everything. Everything good that happens to an artist's career, an artist is responsible for, and everything that's bad about an artist's career, the artist is responsible for."

—*Larry Bell, artist*

"Being an artist is a very, very long game.

It is not a ten-year game."

—*Anish Kapoor, artist*

of the masses. If, on the other hand, they galvanize favorable public opinion or capture the public fancy . . . ? So why not claim this complex of human activity, which every project entails, as the overarching dimension of their artwork?

Of course this "complex of activity," with all of its soap-opera-like twists and turns, was eagerly reported in the local, regional, and sometimes national media. This intensified the drama, the anticipation, and the suspense surrounding Christo and Jeanne-Claude's art.

It took almost three hundred weeks of work to bring "Running Fence" to full realization. When the final sections of the fence were ultimately hoisted, and the billowy white wall became animated in the afternoon wind, almost all of the previous criticism of the project immediately became irrelevant. The miracle of making the almost-impossible happen converted everyone involved with the artwork into an admirer.

As one rancher at the time said, "I thought they [Christo and Jeanne-Claude] were crazy. Most everyone told them they were crazy. . . . People asked them, why do you want to do it? . . . But in the end it was a beautiful sight. . . . It's something we'll never see again."

In spite of all the time, money, and effort that went into making "Running Fence," it physically existed for only two weeks before it was taken down with the same rigorous precision used to erect it. Likewise, the rest of Christo and Jeanne-Claude's more than twenty colossal artworks remained in their completed physical forms for only brief durations. "Valley Curtain" remained in place for a mere forty-eight hours.[11] The Reichstag and the Pont Neuf remained wrapped for just two weeks. "Umbrellas" for 18 days . . .

According to Christo and Jeanne-Claude, their large-scale artworks were really only "complete" when they no longer physically existed.[12] Impermanence, they insisted, was an aesthetic decision. Ephemerality

engenders a sense of poignancy. "Love and tender-
ness" is how they described the feelings aroused by
a beautiful thing predetermined to last for only a few
moments. This transience also had another (though
unspoken) function: it insured the longevity of their
artworks. By erasing the concrete physical evidence,
by eliminating the possibility that their artworks would
ever gracelessly age, Christo and Jeanne-Claude
elevated their art to a legendary, mythic status.[13]

"Art is creating conditions that do not quite exist."

—*Carl Andre, artist*

4. Get others to see things in very specific ways

Some artists want their work to be perceived in a very particular manner. One way they can achieve this is by providing precise and consistent contexts for experiencing their artwork. An artist greatly admired for his skill in making these kinds of contexts—and getting viewers to use them—is Donald Judd (1928–94).

Judd was a so-called Minimalist. ("So-called" because most artists dislike simplistic labels.) Judd was part of an informal group of artists in the early-to-mid 1960s who were intent on stripping away what they thought of as the no-longer-relevant aesthetic preoccupations of the recent art-historical past. These preoccupations included the use of representational imagery, illusionistic pictorial space, and the suggestion of metaphor, allusion, narrative content, emotionality—and even meaning. Instead these artists tried to create artworks with a compelling sense of "presence."

By the time Judd was in his mid-thirties, he had established a vocabulary of artistic elements that he used, more or less, for the rest of his life. It mainly consisted of a few box-like forms, large and small, in two- and three-dimensional iterations. These artworks were made out of sheet metal, plywood, plexiglass, or like materials, and constructed by Judd's employees or commercial fabricators. They were either unpainted, or painted in colors with as few connotative associations as possible. Some boxes were designed to rest on a floor. Others were mounted on walls in either a horizontal or a vertical series. Sometimes there were slight variations between the boxes, but sometimes not.

As enigmatic as Judd's artworks may have appeared to first-time viewers, they did have an intrinsic sensorial appeal. Judd rigorously adhered to the Classical Western aesthetic virtues of harmony and balance achieved through symmetry, repetition, and perfect industrial finishes.[14] What made Judd's artworks extraordinary, however, was not so much how they

"If my work is reductionist it's because it doesn't have elements that people thought should be there. But it has other elements I like."

—Donald Judd, artist

"The better artists are original and obdurate;

they're the gravel in the pea soup."

—*Donald Judd, artist*

looked, but how he made them come alive in the exhibition contexts he created.

Judd was determined that his art be viewed in well-lit, distraction-free spaces where it was placed just so in relation to adjacent art and/or non-art objects. His rationale made a lot of sense: When art and/or other objects and the environment come together in exactly the right way, a new "third something" is created. This precise placement of specific objects in a specific environment came to be known as an "installation."

The exhibition conditions that Judd desired were not always obtainable. According to the artist, most art museum staffs knew what he wanted but sometimes chose to ignore his wishes. Private art galleries did a little better. It was in their interest, after all, to put Judd's artworks in the best possible light to make them salable. Unfortunately, art galleries often sold his work to private collectors and others who, in Judd's opinion, were mostly clueless about how to display it.

After years of frustration, Judd embarked on a mission to buy up as many buildings as he could in Marfa, a small southwest Texas town. (Judd knew Marfa because it was adjacent to a former army base where he had been stationed during his military service.) The buildings were voluminous and attractive in an early-20th-century American no-frills kind of way. Judd cleaned up the interiors and then used them as living, working, and exhibition spaces. In all instances the renovated interiors reflected the artist's meticu-lous-yet-casual clutter-free style, a sensibility wherein almost everything in the room is treated, hence perceived, as "special." Judd also enlisted the financial support of a private art foundation to help him acquire the buildings and land that comprised the entirety of Marfa's decommissioned Army base. His goal, which he largely realized, was to display his and his artist friends' artworks in what he believed to be their appro-priate contexts, in perpetuity.[15]

If a viewer was not at least somewhat knowledgeable about Minimalist art theory, what would plywood boxes on the floor, or metal and plexiglass boxes running up a wall, possibly "say" to them? Probably not much. A viewer needed explanations, or frames of reference, to put what they were seeing into perspective.[16] Art critics and curators have traditionally provided precisely this kind of information, but during the Minimalist-art era, roughly 1963 to 1970, Judd and his artist peers preempted the critics' and curators' roles. They moved quickly and energetically to promote their own theories and contexts that, essentially, instructed viewers about how they should experience what they were looking at.

Judd conveyed his thoughts in forceful, declarative statements delivered with an attitude of absolute certainty. "Actual space is intrinsically more powerful and specific than paint on a flat surface." "The basic nature of art is invisible." "Everything sculpture has, my work doesn't." His statements—pronouncements really—seemed true a priori. They were, in fact, only

personal observations and opinions that sounded rational and often even logical, but sometimes were neither.[17] Nevertheless, Judd's ideas and use of language were so effective that most of the major art critics and museum curators at the time bought into them. They then passed them on to their respective art-viewing publics almost verbatim.

The essence of Judd's perceptual guidance boiled down to this: When confronting one of Judd's artworks, the viewer should grasp it all at once as a unified, coherent whole. No one element of the artwork should be thought of as more important than any other. Furthermore, the viewer should experience the artwork without thinking or musing about anything besides the artwork itself. In other words, no looking for narratives, visual metaphors, or any other imaginative associations. "Experience the existence of my work with nothing else in your mind," Judd pretty much seemed to be saying. He never, however, addressed the meaning of his art. In truth, he may have even rejected the notion

"Art can only exist in a context where,

for whatever reason, it is agreed to, or else

is invited to exist or is permitted to exist."

—*Lawrence Weiner, artist*

"EVERYTHING IS PURGED FROM THIS PAINTING

BUT ART, NO IDEAS HAVE ENTERED THIS WORK."

—*John Baldessari, artist*

of meaning as a relevant concept when it came to his work, or in artworks generally. He was only concerned with encountering "being," the experience of something vividly, palpably present in our awareness.[18]

21OTT

.1974

5. Make things that are meaningful

Was Judd's art actually meaningless? Not really.
Judd was very effective in getting viewers to focus on
"presence," but "meaning"—in the form of allusion,
metaphor, emotionality, etc.—also crept in.[19] Humans
are meaning-seeking animals; we look for meaning
everywhere.[20] Some people actually believe that one of
art's functions is to provide a situation in which the
determination of meaning can be practiced safely.[21]
Some even go so far as to say that art, by definition, is
"meaning embodied," which is another way of saying
that there is no such thing as meaningless art.[22] Alter-
natively stated, an artwork is always more than what it
seems. (Of course this "more" is different from person
to person.) That said, some artworks appear to trigger
an impulse to hunt for meaning to a greater degree
than others. The artworks of the Japan-born New
Yorker On Kawara (1932–2014), for example, seem
especially enticing. Perhaps, ironically, this is because
they seem so opaque.

"Everyone wants to make sense

out of the body of an artist's works

but in fact it's not supposed to make sense,

it is supposed to have meaning."

—Lawrence Weiner, artist

"Art has to be something that makes you scratch your head."

—Ed Ruscha, artist

Kawara is probably best known for a group of almost three thousand paintings cumulatively referred to as the "Today Series." (Individually they are known as "Date Paintings.") The "Today Series" was painted over a span of forty-seven years. Like most of Kawara's other artworks, it was created according to a set of rules or guidelines the artist established for himself.[23] The most noteworthy of the "Today Series" rules were these:

– The date (the paintings' only obvious subject matter) must be centered on the canvas.

– The date must be written following the conventions of the abbreviated day-month-year format of the country in which the painting is made. For example, if a painting is to be made in Rome, it must have the date 21 OTT.1974. Or 21.OKT.1974 if it is to be painted in Vienna. Or OCT. 21,1974 if in New York. In countries that use non-Roman letters, like Japan, Esperanto (a synthetic international language) must be used.

– The date must be painted in white on either a red, blue, or dark gray background. The colors for the background must be mixed specially for each painting.

– Both the letters and numbers must be painted free-hand in a sans-serif font. In other words, no stencils or other mechanical aids are to be used. If there is a subtle evolution of the typeface style from painting to painting, that is okay.

– The paintings must be executed by Kawara himself in acrylic paint on stretched canvas, supported on wood frames, in one of eight horizontally oriented sizes ranging from 8-by-10 inches to 61-by-89 inches.

– If on any given day a painting is begun but not satis-factorily completed by midnight, it must be destroyed.

Each "Date Painting" took Kawara between four to seven hours to complete. They were produced all over the world, but mostly in Kawara's Manhattan studio.

Kawara was not a compulsive painter; he didn't paint every day, and sometimes he went weeks or months without painting at all. Yet on a few days he painted two or three canvases, obviously with the same date, like on November 3, 1989 ("NOV. 3, 1989").

For the first six and a half years of the "Today Series," each painting was given not only a title, which was the date, but also a subtitle. Most of the subtitles were headlines from the major newspaper of the city in which the painting was executed. Often these subtitles seemed like barely veiled political comments. Sometimes Kawara eschewed headlines in favor of what appeared to be personal philosophical realizations or observations on the minutiae of daily life. The following is a small sampling of painting titles—followed by the subtitles:

> **"JAN. 15, 1966"**—"This painting itself is January 15, 1966."

"JAN. 18, 1966"—"I am painting this painting."

"JAN. 30, 1966"—"Snow in New York City."

"JAN. 31, 1966"—"U.S.A. began to bomb North Vietnam again."

"JUNE 17, 1966"—"An 18-year-old girl, Dao Thi Tuyet, poured gasoline over herself in Saigon's Buddhist Vien Hoa Dao Pagoda head-quarters and struck a match."

"JULY 23, 1966"—"I make love to the days."

"FEB. 4, 1967"—"C. Oldenburg and J. Klein came to my studio this afternoon. In the evening I went to Oldenburg's studio to ask him if I could use my asking him as the title of this painting."

"MAR. 18, 1967"—"Today."

"JULY 13, 1967"—"Mostly fair and warm."

"MAY 11, 1969"—"I got up at 12:48 P.M. and painted this."

"NOV. 14, 1969"—"Apollo 12 heads for moon."

"NOV. 19, 1969"—"CONRAD (6:45 A.M.)—' . . . I'm going to step off this pad. Right. Up. Oh, this is soft. Hey, that's neat. I don't sink in too far. I'll try a little—boy, that sun's bright. That's just like somebody shining a spotlight in your hands. I can walk pretty well, Al, but I've got to take it easy and watch what I'm doing. Boy, you'll never believe it! Guess what I see sitting on the side of the crater? The old Surveyor!'"

"JUNE 5, 1970"—"A hijacker held a hand grenade at the neck of a Polish Airlines pilot today and and forced him to fly over Sweden and land in Copenhagen."

"NOV. 11, 1970"—"Maria Addolorata Casalini, 41 years old, gave birth to her 32nd child today in Apulia, Italy, a girl weighing 6.6 pounds. Fifteen of her 32 children survive."

"OCT. 12, 1972"—"Henry A. Kissinger."

"Henry A. Kissinger," the name of a controversial American Secretary of State, was the last evocative subtitle Kawara used. For the remaining forty-plus years of the "Today Series," the only subtitles Kawara employed were the days of the week, like "Wednesday" or "Friday." Or there was no subtitle at all.

Why the change? Perhaps Kawara thought that the cuteness, the horror, or the absurdity of the headlines or the self-reflective observations might mitigate the existential import of the dates alone. The dates alone, after all, suggest something absolutely fundamental about the human condition: our existence occurs in the medium of time. Or perhaps Kawara realized that he

was painting history, but a kind of history that is most effective if all traces of narrative content are removed. Saying more, as the subtitles did, may have had the perverse effect of meaning less. Or, perhaps, Kawara just wanted to depersonalize the titles so that anyone could make that day—the meaning of that particular day—completely her or his own.

Speculating about what was in an artist's mind, or what an artist intended, is one of the strategies a viewer might use when seeking out an artwork's meaning. At every turn, however, Kawara thwarted the viewer's efforts to get a handle on who he was or what he thought. He never went to the openings of any of his art exhibitions. He gave no talks and submitted to no interviews. He left no writings explaining what his art meant. And since his arrival in the United States from Japan in his twenties, there are no public photographs of him except a few of the back of his head. Additionally, Kawara never insisted that his artworks be displayed in any particular way except, obviously, in a general art

"It's been said many times . . . that one can find some of painting's meanings by looking not only at what painters do but at what they refuse to do."

—*Ad Reinhardt, artist*

context—but sometimes not even that. Beginning in 1998, he began an open-ended project titled "Pure Consciousness." A selection of his "Date Paintings" was installed in various kindergarten classrooms around the world. No explanation was given to the children for the sudden appearance of these painted canvases. Nor were the children subjected to an organized discussion about these new artifacts. The paintings simply functioned as a backdrop for the children's work and play. No one knows what the children thought of them—or if they thought of them at all.

Each of our overly large brains manufactures meaning. Our intellects cannot let something we perceive as a possible pattern go by without having the thought, "Surely it must mean something." And what does an artwork suggest if not, "I was made to convey some manner of meaning. Can you guess what that meaning is?" Of course, there is no way to prove this or that meaning. Who really knows? The artist who makes the

work of art has no better idea of what it "really" means than the astute critic.[24]

And so, it is possible that Kawara spent forty-seven years of his life doing "senseless" work that resulted in a lot of "dumb," albeit painstakingly crafted, paintings. But even if this were the case, Kawara's tenacious commitment to the exacting, repetitive act of painting takes on a meaning of its own. The "why" of it insinuates itself into the curious viewer's mind. The curiosity invariably leads to questioning. And the questioning activates a creative process that inevitably leads to the production of meaning.

"All in all, the creative act is not performed by the artist alone; the spectator brings the work in contact with the external world by deciphering and interpreting its inner qualifications and thus adds his contributions to the creative act."

—*Marcel Duchamp, artist*

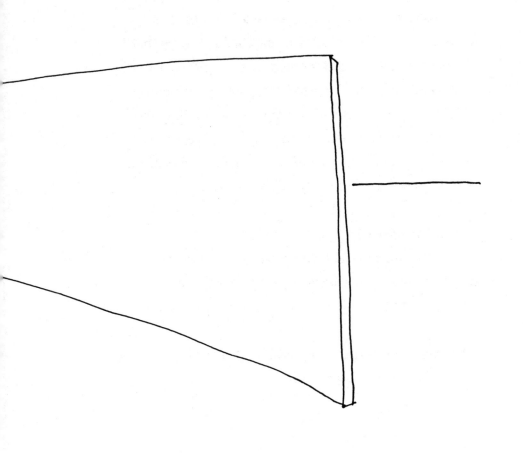

6. One more thing . . .

Is it possible that the entire art-making enterprise is little more than a sophisticated aesthetic pastime that absorbs time and creative energy that might otherwise go toward destructive ends? Perhaps. However, the late president John F. Kennedy didn't think so. He thought that artists do something rather important. He thought that artists contribute something of significant positive value to society. In Kennedy's words:[25]

"The artist, however faithful to his personal vision of reality, becomes the last champion of the individual mind and sensibility against an intrusive society and an officious state."[26]

"We must never forget that art is not a form of propaganda; it is a form of truth. . . ."

"When power corrupts, poetry cleanses. For art establishes the basic human truths which must serve as the touchstone of our judgment."

"When power narrows the area of man's concern, poetry reminds him of the richness and diversity of his existence."

"In pursuing his perceptions of reality, [the artist] must often sail against the currents of his time. This is not a popular role."

"The highest duty of . . . the artist is to remain true to himself and to let the chips fall where they may."

Today it may be difficult to imagine an American president praising artists for their idiosyncratic and nonconforming ways. It may be even harder to imagine the nation's leader actually encouraging artists to do what they must and "let the chips fall where they may." Kennedy, the leader, was a man of conviction. He

believed that artists should commit themselves to their individualistic paths even if—especially if—it runs counter to the fashionable beliefs, opinions, and powers of the day.[27]

As a result of Kennedy's leadership, it became national policy to incorporate the work of a living American artist in new federal building projects, whenever appropriate. In 1979 an original artwork was sought for Foley Square (also known as Federal Plaza) in Lower Manhattan. Foley Square was at the center of one of the densest clusters of government employees in the country. In one building alone there were over ten thousand workers. After serious consideration, artist Richard Serra (1939–) was awarded the commission.

Serra seemed like a reasonable choice. He, like Judd, had been successful in getting viewers of his sculptures to "see" and think about them in a unique way. His work struck an interesting balance between the

"... the familiar identity of things has to be pulverized in order to destroy the finite associations with which our society increasingly enshrouds every aspect of our environment."

—*Mark Rothko, artist*

". . . the most interesting thing for an artist

is to pick through the debris of a culture, to look at

what's been forgotten or not really taken seriously.

Once something is categorized and accepted,

it becomes part of the tyranny of the mainstream,

and it loses its potency."

—*David Bowie, artist*

pleasing and the provocative. He used materiality in novel ways. And he was capable of working on a large scale. In 1981, after extensive engineering studies and prolonged negotiations, a Serra sculpture was installed in Foley Square. It was titled "Tilted Arc." It was composed of three 2½-inch-thick plates of corten steel—a type of steel designed to develop a thin, permanent patina of rust. It was 120 feet long and 12 feet high and weighed 73 tons. As its name implies, once in place the wall-like steel plates tilted slightly. They remained upright because of the way they gently arced across the plaza. In so doing though, the plaza was effectively cut in two.

The bisection of Foley Square by "Tilted Arc" changed the way in which the plaza was perceived and used. Some people lauded the sculpture as a breakthrough work of art, but others condemned it as overbearing and oppressive. It blocked vistas and forced changes in customary walking routes. It was, undeniably, a challenging artwork imposed on a largely non-art-interested

public. The following sentiment was voiced by a clerk in one of the adjacent federal buildings: "[Foley Square is] not a great plaza by international standards, but it is a small refuge and place of revival for people who ride to work in steel containers, work in sealed rooms, and breathe re-circulated air all day. Is the purpose of art in public places to seal off a route of escape, to stress the absence of joy and hope? I can't believe that this was the artistic intention, yet to my sadness this for me has been the dominant effect of the work, and it's all the fault of its position and location."[28]

At the time, Serra did not seem to care what others thought or felt. In the artist's words, "When I conceive a structure for a public space, a space people walk through, I consider the traffic flow, but I do not necessarily worry about the indigenous community. I am not going to concern myself with what 'they' consider to be adequate, appropriate [artistic] solutions."[29]

"When working in galleries or museums, I assumed that I could do anything to a viewer, because people entering galleries and museums are effectively saying, 'I'm allowing myself to be a victim of art.'"

—*Vito Acconci, artist*

Eight years after the sculpture was installed, after rancorous public debates, many lawsuits and appeals, and much animosity on all sides, it was decided that the United States government was free to remove "Tilted Arc" from the plaza. Immediately thereafter the sculpture was dismantled and moved to a storage facility. Serra was outraged. All along he had insisted that "Tilted Arc" was a site-specific work of art and to move it to any other location would mean destroying it. Among other things, Serra complained that this was an egregious example of the American legal system's preference for capitalistic property rights over democratic freedom of expression.

"Tilted Arc" turned out to be one of the most contentious sculptures of the 20th century. It came into existence—as all works of art do—because an artist—Serra in this case—willed it to. Will is a kind of force. Force often meets with resistance. The point of resistance can be, as President Kennedy suggested, an occasion for an edifying truth. The truth for Serra may have been

that making art to needlessly provoke confrontations is a dubious use of one's time and energy. Serra continued using the same materials—rusted steel rendered in gravity-defying arcs—to create massive new sculptural forms. But he subsequently situated these works in more art-inviting contexts. Over time these pieces, with names like "Inside Out," "Snake," "Torqued Ellipses," and "Tilted Spheres," became some of the most universally beloved sculptures of the early 21st century.

"Tilted Arc" was an exception to the general rule that making art is, truly, a peaceful and socially responsible activity. Yet, most artists have their "let the chips fall where they may" moments. Duchamp had many. So did Cage, Christo and Jeanne-Claude, Judd, and even Kawara. In their distinct ways, each of these artists turned their back on the manner in which things "should be" done and let the consequences play out.

In actuality, in order to make "significant" art, an artist must in some manner break away from the status quo. Conflicts may result. Still, compared with other "revolts," artistic revolutions—remarkably—rarely cause more damage than bruised egos. This may not seem like a big thing. If you think carefully about it though, this is not a small thing either.

Text notes

1. In the context of this book, the lofty prices paid at auction for works of art do not qualify as a measure of art's value. Nor does the improvement in academic test scores of children who attend regular art classes. Nor does the superior cognitive functioning of infants who are exposed to Mozart early in life. Etc.

2. That is, if "anyone" is a human being. In the future art may be conceived and made solely by machines for other machines, but presently art is only made by humans for humans—although machines may be used in the process.

3. Curators and other institutional gatekeepers also determine what art is. Nevertheless, at the present time it is generally accepted that if a "bona fide" artist says something is art, it is indeed art.

4. Duchamp's fondness for game playing was so great that, later in life, rumors circulated that he had given up art for chess. This was not true.

5. According to Morton Feldman, an artistic peer and contemporary of Cage's, "[He] was the first composer in the history of music who raised the question by implication that maybe music could be an art form rather than a music form." This is from an article titled "Searching for Silence" by Alex Ross, which appeared in the *New Yorker* on October 4, 2010. Ross writes: "Feldman meant that, since the Middle Ages, even the most adventurous composers had labored within a craftsman-like tradition. Cage held that an artist can work as freely with sound as with paint: he changed what it meant to be a composer, and every kid manipulating music on a laptop is in his debt."

6. Like much of Cage's work, "4' 33"" falls into an aesthetic category that could be described as the

"Art is in relation to its society a service industry."

—*Lawrence Weiner, artist*

"didactic" or the "pedagogic;" that is, art that is primarily intended to make a point or instruct. A subcategory of the didactic could be called "Let's pay attention to the obvious." In other words, this is art that expresses or shows—or, with gentle guidance, allows to be experienced—that which already exists but is usually ignored or not experienced fully because it seems too inconspicuous or too omnipresent, or because people are just too preoccupied (or jaded) to notice.

7. One of the post-Cage artists who also made something out of nothing is Lawrence Weiner (1942–). A representative Weiner artwork is the following words painted on the wall of an art gallery (or the side of a building or a like structure):

ONE QUART GREEN
EXTERIOR INDUSTRIAL ENAMEL
THROWN ON A BRICK WALL

Weiner contends that these words in and of themselves are sculpture that need not be realized in a physical form. According to the artist, sculpture involves processes such as "taking out" and "putting in," which are events that ultimately take place in the mind. Weiner's entire body of art consists of words describing "sculptural events," logical arguments presented in stand-alone statements, and thoughts conveyed in interviews. Altogether Weiner convincingly establishes a parity between his "mental" sculptures and more traditional sculptures made of wood, bronze, steel, clay, etc.

8. Christo and Jeanne-Claude tried to wrap things that were as culturally resonant as possible. For example, wrapping the Reichstag, which is rich in symbolism and historical associations, is the political equivalent of wrapping the Capitol Building in Washington, D.C., and then some. Originally built in 1894, the Reichstag was burned in 1933. Hitler used the burning as a pretext for an emergency decree to

". . . for a work of art to be a work of art,

it must rise above grammar and syntax . . ."

—*Barnett Newman*

suspend civil liberties in Germany—which marked the beginning of the end. . . . The building was eventually restored in the 1960s. It was, and still remains, the quintessential symbol of a democratic Germany.

9. For example: How is an 18-foot-high fabric fence going to withstand sustained daily winds in excess of 40 miles an hour? What kind of fence-support system will be necessary? Etc. The possible solutions then had to be tested, and retested. . . .

10. Some of the actual objections to "Running Fence" included such things as:
 – The possibility that excessive noise would be generated when the fence fabric flaps in the wind.
 – The possibility that animals might injure themselves if they tripped over the guy-lines supporting each fence pole.
 – The possibility that private planes, flying low to see the fence, might be caught off guard by an unexpected updraft and crash.

‒ The possibility that the entire project is simply a self-serving scheme to enrich the artists.

11. "Valley Curtain" was supposed to have remained in place for two weeks, but twenty-eight hours after completion a gale-force wind necessitated its removal. At the time Christo and Jeanne-Claude said that the artwork had been physically manifested, although briefly, so there was no need to redo it.

12. Of course, all of Christo and Jeanne-Claude's projects were amply documented by photographers the art duo commissioned.

13. Another element of Christo and Jeanne-Claude's large-scale projects also attracted and sustained attention. This was the projects' funding. Obviously, vast sums of money were needed. The final cost of "Running Fence" alone was three million dollars (well over twenty million in 2018 dollars). Many people wondered: Who is paying for the engineering

reports? The manufacturing of all the material and support structures? The salaries of all the installers? The insurance and surety bonds? The security and trash removal services? The lawyers and other professional fees, etc.? The short answer was that the money came from Christo and Jeanne-Claude's bank account.

Like most artists who are not independently wealthy, Christo and Jeanne-Claude had to think like resourceful entrepreneurs. Unlike most artists, they eschewed grants from corporate sponsors, foundations, and governments. They often stated that they did not want "strings attached" to the money they obtained; they wanted to insure their artistic independence. So they devised a scheme whereby every project's preparatory and planning drawings, collages, models, and prints were pre-sold at a generously discounted rate. This, according to Christo and Jeanne-Claude, was the source of their project funding.

In reality the buyers were many of the same people and institutions Christo and Jeanne-Claude said they wanted independence from. Nevertheless, selling completed pieces of art is different from asking for money for an art project in the planning stage. There are, in fact, fewer strings attached.

This "independent" way of project financing gave Christo and Jeanne-Claude an added aura of integrity that increased the esteem for, and curiosity about, what they were up to.

14. Judd sometimes constructed his artworks out of unpainted plywood, which is normally not considered a material with a "perfect industrial finish." Judd, however, seemed aligned with the basic Modernist notion of respecting the "honesty" of materials. In this sense, unfinished plywood is, in fact, "perfectly, honestly, plywood."

15. Judd was very supportive of other artists he felt

an aesthetic kinship with. In his five-story loft building in the Soho district of Manhattan (which he retained even after moving to Marfa) there was—and still is—a highly curated "placed just so" collection of his and his friends' artworks.

16. There was not a lot of precedent for the kind of artwork that Judd made. However, the artworks and words of Barnett Newman, a philosophically inclined painter and sculptor twenty-five years Judd's senior, set the stage, conceptually speaking, for what Judd made.

17. For asserting authority, it is hard to beat the power of a simple declarative sentence. Declarative sentences seem true even when they're not. "All men are created equal" seems like it ought to be true, but is it? (If it is true, how so?) Fortunately, artists don't have to be logical, consistent, or even make sense. "The main thing wrong with painting is that it is a rectangular plane placed flat against

the wall," Judd wrote in his most widely known essay, "Specific Objects." In the same essay he wrote, "Except for a complete and unvaried field of color or marks, anything spaced in a rectangle and on a plane suggests something in and on something else, something in its surround, which suggests an object or figure in its space, in which these are clearer instances of a similar world—that's the main purpose of painting." Huh?

18. Artists often engage in a kind of "pure research" for the rest of society. Judd's exhibition ideas, for example, became conspicuously absorbed by the "brand marketing" trades, especially when it comes to the merchandising of sophisticated and so-called luxury goods. Branding, advertising, and marketing agencies, and even architectural practices, routinely send teams of employees to Marfa to study and experience Judd's work in its most comprehensive presentation. Judd's ideas and aesthetic sensibility are in evidence every-

where, not just in the formal art-viewing venues. In Marfa it becomes clear how the contexts that Judd created and enforced can ennoble almost any object by getting viewers to focus on the uniqueness, the wonder—and even the beauty—therein.

19. In spite of Judd's efforts to get viewers to mentally disassociate meaning, allusions, metaphor, etc. when viewing his work, it was and is nearly impossible. A case in point is a dialogue between the art historians Shana Gallagher-Lindsay and Beth Harris on the Kahn Academy website. Here they are discussing one of Judd's stacked box pieces:

Shana: "It is what it is. It doesn't disguise itself. He's [Judd] very clear about not wanting to make illusionistic art. So he doesn't want to make a sculpture to look like a person or a space that isn't there. They are clearly boxes. . . ."

Beth: "Reminds me of skyscrapers and

"Nearly everything around us that we have any control of is based on how well things work together. I mean, one furnishes a room with what fits into that room nicely, on what goes together, and I think it is an enormous influence on us. And the thing that's so exciting about art is that it doesn't have to get along."

—*Robert Rauschenberg, artist*

other kinds of Modernist forms. . . ."

20. "Meaning" is not necessarily something that can be, or has to be, articulated in words. It could be something that is felt, or sensed, or simply enjoyed.

21. This can be fun. We use all of our resources—sensorial, intellectual, intuitive—to make sense of things. In so doing we sharpen our skills in determining shaded, veiled, obscured, and unintended meanings that may cross over into the "real world."

22. Art as "meaning embodied" is a phrase used by the late philosopher and art critic Arthur Danto. Danto was captivated by the following Duchamp-inspired problem: "What makes a work of art different from something that looks exactly the same but is not a work of art?" Danto began ruminating on this philosophical problem upon first seeing Andy Warhol's Brillo Box artworks, which were silk-screened replicas of actual Brillo soap pad boxes.

Danto concluded that once something is identified as a work of art, we think about it in a completely different way from how we think about things that are not works of art. And this "thinking about" invariably yields meanings and interpretations.

23. Most of Kawara's artworks were created in series according to sets of rules that the artist established for himself. In one serial artwork running from 1968 through 1979, Kawara sent at least one picture postcard a day to a friend or colleague with the words "I GOT UP" rubber-stamped on the back. Also stamped was the exact time he got up. (It is unclear whether Kawara meant "woke up" or "got out of bed.")

In another serial piece created during this same eleven-year period, Kawara typed a list of all the people he interacted with that day—friends, acquaintances, and strangers—on a sheet of letter-sized paper. Each day's list was then methodically assem-

bled in a well-organized binder with the lists from previous days. He titled this artwork "I MET."

In yet another serial piece around this same time, Kawara sent out nearly nine hundred telegrams to friends and associates around the world bearing only the terse statement, "I AM STILL ALIVE."

24. Artists are certainly entitled to explain what they think their artwork is about, but it's only their opinion—an opinion from a rather myopic point of view. In fact, even if an artist intended that their work mean this or that, they would not be the best judge of its success or failure. A good starting point for further discussion of this issue is the essay "The Intentional Fallacy" by critic W. K. Wimsatt and the aesthetician Monroe Beardsley. Therein the two thinkers argue that once an artwork is completed and begins its life as an independent entity, the artist has no more authority over, or valid critical insight about, the artwork's meaning than

"There is no real separation line, only an intellectual one, between the object and its time environment. They are completely interlocking: nothing can exist in the world independent of all the other things in the world."

—*Robert Irwin, artist*

anyone else. They even advise not to take what an artist says about their work too seriously.

25. Kennedy made these points in a speech he delivered at Amherst College in Massachusetts on October 26, 1963, less than a month before his untimely death. The occasion was the groundbreaking for a library named in honor of the poet Robert Frost—and the awarding of an honorary degree to Kennedy. The following lines from a famous Frost poem were also noted in Kennedy's remarks:

"Two roads diverged in a wood, and I—
I took the one less traveled by,
And that has made all the difference."

26. The linguistic conventions of Kennedy's time were not as sensitive to the use of personal pronouns as they are at present. Today Kennedy undoubtedly would have used "her or his," or a non-gendered pronoun like "they" when referring to artists.

27. In other words, artists do not do "market research" before commencing on a project. "Giving people what they want" is not generally the way artists do things.

28. From the essay "Minimalism and the Rhetoric of Power" by Anna C. Chave, included in the book *Power: Its Myths and Mores in American Art, 1961–1991*, edited by Holliday T. Day (Indianapolis Museum of Art, 1991), page 138.

29. From an interview with Serra reproduced in the essay "An Atmosphere of Effrontery" by Casey Nelson Blake in *The Power of Culture: Critical Essays in American History*, edited by Richard Wrightman and T. J. Jackson Lears (University of Chicago Press, 1993). Reproduced in the book *Visual Shock: A History of Art Controversies in American Culture* by Michael Kammen (Alfred A. Knopf, 2006), page 239.

Quotation sources

PAGE 5 From "The Talk of the Town" section of the
 New Yorker, January 18, 2016.

PAGE 6 The first two sentences from the book *The
 Story of Art* by E. H. Gombrich (Phaidon, 1950).

PAGE 8 From *Interviews with American Artists* by
 David Sylvester (Yale University Press, 2001).

PAGE 11 From the article "Everything in Sight: Robert
 Rauschenberg's New Life" by Calvin Tomkins
 in the *New Yorker*, May 23, 2005.

PAGE 12 From an oral interview conducted on
 July 15, 1974. Held in the Archives of Ameri-
 can Art, Smithsonian Institution.

PAGE 15 From *Interviews with American Artists* by
 David Sylvester (Yale University Press, 2001).

PAGE 19 From the lecture titled "The Creative Act,"
 published in *ArtNews* 56, no. 4 (Summer

1957). Reproduced in *Theories and Documents of Contemporary Art: A Sourcebook of Artist's Writings,* edited by Kristine Stiles and Peter Selz (University of California Press, 1996).

PAGE 20 From *Lawrence Weiner* by Alexander Alberro et al. (Phaidon Press, 1998).

PAGE 25 From "Marcel Duchamp: Anti-Artist," reprinted in *The Dada Painters and Poets: An Anthology*, edited by Robert Motherwell (Belknap Press, 1989).

PAGE 26 From *Inside the Studio: Two Decades of Talks with Artists in New York*, edited by Judith Olch Richards (Independent Curators International, 2004).

PAGE 32 From the document/catalog titled "January 5-31" (Seth Siegelaub, 1969).

PAGE 39 From the lecture titled "Lecture on Nothing," reprinted in *Silence: Lectures and Writings* by John Cage (Wesleyan University Press, 1973).

PAGE 45 From *Portraits: Talking with Artists at the Met, the Modern, the Louvre and Elsewhere* by Michael Kimmelman (Random House, 1998).

PAGE 46 Artist Richard Serra's quote is excerpted from this longer quote by artist Chuck Close: "Richard Serra once gave me one of the great pieces of advice: 'If you really want to sepa-rate your work from everyone else's, every time you come to a Y in the road, don't think about which way to go; automatically take the toughest route. Everybody else is taking the easiest one. . . .'" Published in *Inside the Studio: Two Decades of Talks with Artists in New York*, edited by Judith Olch Richards (Independent Curators International, 2004).

PAGE 49 From "How Art Went Back to Basics: Fifty Years After Its Opening; The Pioneers of Minimalism Recall the Groundbreaking Exhibition Primary Structures," published in *Art Newspaper* (April 2016).

PAGE 50 From an oral interview with John Tusa on BBC Radio 3 (July 6, 2003).

PAGE 56 From *Cuts: Texts, 1959–2004*, edited by James Meyer (MIT Press, 2005).

PAGE 59 From *Minimal Art: A Critical Anthology*, edited by Gregory Battcock (University of California Press, 1995).

PAGE 60 From *Donald Judd: Complete Writings 1975-1986* (Van Abbe Museum, 1987).

PAGE 65 From *Having Been Said: Writings and Interviews of Lawrence Weiner 1968–2003*, edited by Gerti Fietzek and Gregor Stemmrich (Hatje Cantz Publishers, 2004).

PAGE 66 The text painted on a canvas by John Baldessari titled "Everything Is Purged From This Painting But Art, No Ideas Have Entered This Work."

PAGE 71 From *Lawrence Weiner* by Alexander Alberro
 et al. (Phaidon Press, 1998).

PAGE 72 From *Ed Ruscha* by Richard D. Marshall
 (Phaidon Press, 2003).

PAGE 80 From the essay "Abstract Art Refuses,"
 published in *Art-as-Art: The Select-
 ed Writings of Ad Reinhardt*, edited by
 Barbara Rose (Viking Press, 1953).

PAGE 83 From the lecture titled "The Creative Act,"
 published in *ArtNews* 56, no. 4 (Summer
 1957). Reproduced in *Theories and Documents
 of Contemporary Art: A Sourcebook of Artist's
 Writings,* edited by Kristine Stiles and Peter
 Selz (University of California Press, 1996).

PAGE 89 From *Minimalism: Art of Circumstance* by
 Kenneth Baker (Abbeville Press, 1988).

PAGE 90 From an interview in the *New York Times*
 by Michael Kimmelman (June 14, 1998).

PAGE 93 From *Inside the Studio: Two Decades of Talks with Artists in New York*, edited by Judith Olch Richards (Independent Curators International, 2004).

PAGE 101 From *Lawrence Weiner* by Alexander Alberro et al. (Phaidon Press, 1998).

PAGE 104 From the essay "Barnett Newman: The Living Rectangle," published in *The Anxious Object* by Harold Rosenberg (University of Chicago Press, 1964).

PAGE 112 From an interview with Robert Rauschenberg in *Interviews with American Artists* by David Sylvester (Yale University Press, 2001).

PAGE 116 From *Seeing Is Forgetting the Name of the Thing One Sees: A Life of Contemporary Artist Robert Irwin* by Lawrence Weschler (University of California Press, 1982).

PAGE 127 These are the words, written in cursive script, on a lithographic print titled "I Will Not Make Any

More Boring Art" attributed to artist John Baldessari (1931–). The print evolved from a proposal Baldessari made to art students to write these words, in the manner of a mock punishment, on the walls of an art school gallery. The same students later provided the cursive script for the print. "I Will Not Make Any More Boring Art" was produced after Baldessari had all of his previous paintings cremated—in a crematorium—supposedly in response to his disillusionment with his artwork, in particular, and disgust with the state of painting in general. At the time Baldessari was thirty-nine years old.

"I will not make any more boring art.

I will not make any more boring art.

I will not make any more boring art.

I will not make any more boring art.

I will not make any more boring art.

I will not make any more boring art.

I will not make any more boring art.

I will not make any more boring art.

I will not make any more boring art.

I will not make any more boring art.

I will not make any more boring art.

I will not make any more boring art.

I will not make any more boring art.

I will not make any more boring art.

I will not make any more . . ."

—*John Baldessari, artist*